You have been described both as a 'super-collector' and as 'the most successful art dealer of our times'. Looking back on the past 20 years, how would you characterise your a

You have been described both as a 'super-collector' and as 'the most successful art dealer of our times'. Looking back on the past 20 years, how would you characterise your activities?

Who cares what I'm described as? Art collectors are pretty insignificant in the scheme of things. What matters and survives is the art. I buy art that I like. I buy it to show it off in exhibitions. Then, if I feel like it, I sell it and buy more art. As I have been doing this for 30 years, I think most people in the art world get the idea by now. It doesn't mean I've changed my mind about the art that I end up selling. It just means that I don't want to hoard everything forever.

What do you look for when buying a work of art?

There are no rules I know of.

Which do you enjoy more: the hunt involved in collecting or the pleasure of owning major works of art?

Both are good.

Your practice of buying emerging artists' work has proved highly contagious and is arguably the single greatest influence on the current market because so many others, both veteran collectors and new investors, are following your lead, vying to snap up the work of young relatively unknown artists. Do you accept that you are responsible for much of the speculative nature of the contemporary art market?

I hope so. Artists need a lot of collectors, all kinds of collectors, buying their art.

Whom, if anyone, do you listen to for advice when buying art?

Nobody can give you advice after you've been collecting for a while. If you don't enjoy making your own decisions, you're never going to be much of a collector anyway. But that hasn't stopped the growing army of art advisers building 'portfolio' collections for their clients.

Do you feel a sense of personal responsibility towards the artists whose work you collect? Artists who benefited from your patronage in the late 1970s and early 1980s, such as Sean Scully and Sandro Chia, felt an acute sense of betrayal when you offloaded their work in bulk onto the market. In the case of Chia, you have been accused of having destroyed his career. Do you regret how you handled these artists' works?

I don't buy art to ingratiate myself with artists, or as an entrée to a social circle. Of course, some artists get upset if you sell their work. But it doesn't help them whimpering about it, and telling anyone who will listen.

Sandro Chia, for example, is most famous for being dumped. At last count I read that I had flooded the market with 23 of his paintings. In fact, I only ever owned seven paintings by Chia. One morning I offered three of them back to Angela Westwater, his New York dealer, where I had originally bought them, and four back to Bruno Bischofberger, his European dealer, where, again, I had bought those. Chia's work was tremendously desirable at the time and all seven went to big-shot collectors or museums by close of day.

If Sandro Chia hadn't had a psychological need to be rejected in public, this issue would never have been considered of much interest. If an artist

is producing good work, someone selling a group of strong ones does an artist no harm at all, and in fact can stimulate their market. As for Sean Scully, I did own about five of his works but as his paintings now sell for $800,000+ at auction, I don't think it sounds like I've destroyed his market completely.

Before you went into advertising, what other career did you consider?

Before you went into advertising, what other career did you consider?

'Consider' isn't quite how it was. At 17 and with two 'O' Levels to show after a couple of attempts, a career path wasn't realistic, nor a chat with the Christ's College Careers Officer, who wouldn't have recognised me in any event as my absenteeism record was unrivalled.

I answered a situations vacant ad in the *Evening Standard* for a Voucher Clerk, pay £10 weekly. It was in a tiny advertising agency in Covent Garden, and a voucher clerk had to traipse round all the local newspaper offices in Fleet Street, of which there were hundreds at the time, and pick up back copies of papers in which the agency's clients had an advert appearing. The voucher clerk's role was to get the newspaper, find the ad, stick a sticker on it so the client could then verify its appearance, and the agency could get paid. Vital work, obviously.

One of the advantages of it being a tiny agency is that one day they got desperate when their Creative Department (one young man) was off sick, and they asked me if I could try and make up an ad for one of their clients, Thornber Chicks. This ad was to appear in *Farmer & Stockbreeder* magazine, and hoped to persuade farmers to choose Thornbers, as their chicks would grow to provide many cheap, superior quality eggs and a fine return.

I didn't know how you write an ad, or indeed how to write anything much other than 'I will not be late for Assembly', for which I had been provided much practice. So I looked through copies of *Farmer & Stockbreeder* and *Poultry World*, chose some inspiring-sounding words and phrases, cobbled them together, stuck on a headline – I think I stole it from an old American advertisement – and produced 'Ask the man who owns them' as a testimonial campaign featuring beaming Thornber farmers. The client bought it.

Does a love of art, particularly Renaissance art on a biblical theme, make one feel closer to God?

Does a love of art, particularly Renaissance art on a biblical theme, make one feel closer to God?

I believe God must be very disappointed in his handiwork. Mankind has clearly failed to evolve much in all these years; we're still as cretinous and barbaric as we were many centuries ago, and poor God must spend all day shaking his head at our vileness and general ineptitude. Or perhaps, we might just give him a good laugh. But of course, I hope God likes our art enough to forgive us our sins, particularly mine.

What is the most honest thing you can say about yourself?

My name is Charles Saatchi and I am an artoholic.

What was your first break in advertising?

After being rejected for a copy test by J. Walter Thompson, Young & Rubicam, Ogilvy & Mather, and failing at interviews, or to even get an interview at every other agency I could think of, I managed to wriggle my way into an appointment to see Jack Stanley, the creative director of Benton & Bowles.

God knows why he agreed to see me, or what he saw in this gormless youth sat in front of him, but he was American, noted that I seemed mad about all things American and knew a little about American ads, and could start immediately.

Literally immediately, because he promptly walked me down a corridor, told me he had hired another young trainee last week, and I was to work with him. Luckily for me the trainee was John Hegarty, and we hit it off, and even better he was very talented and I would look good bathed in his afterglow.

With Mark Rothko's paintings, people say that they evoke 'infinity'. Do you see it this way?

With Mark Rothko's paintings, people say that they evoke 'infinity'. Do you see it this way?

My understanding of infinity goes something like this: every 100 years a sparrow flies to the top of a large mountain, and cleans its beak by scraping it on the highest rock. By the time the mountain has been scraped away to a small pile of dust, that would be the equivalent of the first second of infinity.

I thought of that the last time I stood in front of a Rothko and neither felt an overwhelming sense of infinity, nor had a mystical experience of any kind.

Maybe I've just seen too many Rothkos and they don't pulsate with ethereal splendour for me anymore. Or perhaps I never quite got the wonder of Rothko.

Did your parents instill in you an interest in art?

Not that I noticed, but who am I to say what unconscious inspiration they provided, or whether deep in my genetic make-up there was a chimpanzee that liked to draw in the dirt with a stick.

Do you wash your hands after you have had a wee?

I have an acute sense of hygiene so I wash my hands before I have a wee.

Everyone I know in advertising talks about the era of the CDP agency in the late 1960s as the 'golden years'. Is this old men just being nostalgic?

CDP was the world's cleverest and most provocative agency that specialized in ads that actually had the public looking forward to commercial breaks. I was very lucky to get into CDP in 1966, on the coat-tails of working with Ross Cramer as an art director/copywriter team. CDP's creative director didn't really care about me, but he wanted Ross very much, and reluctantly ended up with young Saatchi as part of the package.

The creative director was the dour and reticent Colin Millward, as close to an advertising genius that Britain would produce, and with a magnificent North Country accent. He dismissed my copywriting efforts as piss-poor, but patiently helped me get better, in what became a delightful relationship. Fortunately for me I also found an ally in David Puttnam, a young account manager who at the time was a super-cool Paul McCartney lookalike, who sold my campaigns to some high profile clients, which did me no harm at all.

As David wrote in Colin Millward's obituary in 2004 all the best creative people in advertising learnt it all from Colin, and even learnt that if you didn't really have a decent idea, give the commercial to Ridley Scott and he would turn a brainless 30

seconds into something exotic and widely admired. Colin also knew that if you wanted some gentle English humour and a nice play-on-words in the headline ('When it rains it shines' for Ford's new super-glossy paint finish), you would go to my next door neighbour down CDP's corridor, Alan Parker.

And if you wanted something basic and crude you would come to me and hope for the best.

Note: David Puttnam went on to win an Oscar for Best Picture with *Chariots of Fire* and is now Lord Puttnam.

Ridley Scott went on to make *Alien*, *Blade Runner*, *Thelma and Louise*, *Gladiator*, *American Gangster* and *Hannibal*. He became Sir Ridley Scott in 2003.

Alan Parker went on to make *Bugsy Malone*, *The Commitments*, *Mississippi Burning*, *Midnight Express* and *Evita*. He became Sir Alan Parker in 2002.

Are you ever concerned about your influence on taste, when it comes to contemporary British art? Does it worry you that your purchases (or sales) have an impact on the market? Or is this something you enjoy?

I never think too much about the market. I don't mind paying three or four times the market value of a work that I really want. Just ask the auction houses. As far as taste is concerned, I primarily buy art in order to show it off. So it's important for me that the public respond to it and contemporary art in general.

Do you think speculation has inflated prices for contemporary art over the last decade? Do you expect the bubble to burst soon?

Yes. No.

How do you decide what to sell and when to sell it?

There is no logic or pattern I can rely on. I don't have a romantic attachment to what could have been. If I had kept all the work I had ever bought it would feel like Kane sitting in Xanadu surrounded by his loot. It's enough to know that I have owned and shown so many masterpieces of modern times.

What made you decide to open a gallery to the public? Did you feel it was some sort of public duty or were there more pragmatic reasons?

As I stated earlier, I like to show off art I like.

Do you believe in philanthropy? Do you believe that people who are rich and successful have a responsibility towards society?

The rich will always be with us.

How do you choose what to buy? Is it about what you like, or will you buy things you don't like as an investment?

The more you like art, the more art you like. So I find it easy to buy lots of it, and seeing art as an investment would take away all the fun.

You are a generous lender to exhibitions. However, some of your donations to art schools and colleges are arguably just a way of purging your collection of second-rate art that will be hard to sell. Is this a fair judgement?

The artists whose work I have given to the national collections probably wouldn't thank you for your judgement of their work. And, for example, a large five-panelled Glenn Brown work I gave to the Arts Council would be easy to sell, and for about $500,000. I obviously like the work I give away, otherwise I wouldn't have bought it. But would I be a nicer person if I gave away all the most popular works in my gallery?

Glenn Brown, *Exercise One*, 1995
Five panels, each 192 × 139 cm (75⁵/₈ × 54³/₄ in)

I like the new gallery but hated your gallery in County Hall. What were you thinking!

I was stupid, stupid, stupid.

I got bored with knowing my first gallery in Boundary Road too well, so well in fact that I could hang my shows to the centimetre whilst sitting on a deckchair in Margate. Plus, I wanted to introduce new art to as wide a public as possible, and I went for somewhere with a much bigger footfall on the South Bank next to the London Eye.

So I gave up the airy lightness of Boundary Road for small oak-panelled rooms, and nobody liked it. I saw it as a challenge, but one which I clearly wasn't up to.

Which artists do you display in your own home? Are you constantly changing the works you have there? Is there a core of favourites which stay there?

My house is a mess, but any day now we'll get round to hanging some of the stacks of pictures sitting on the floor.

Have you ever fallen in love with the work of an artist whose work was not sellable, for example, a performance artist or someone who creates massive public installations?

Lots of ambitious work by young artists ends up in a dumpster after its warehouse debut. So an unknown artist's big glass vitrine holding a rotting cow's head covered by maggots and swarms of buzzing flies may be pretty unsellable. Until the artist becomes a star. Then he can sell anything he touches.

But mostly, the answer is that installation art like Richard Wilson's oil room [purchased by Saatchi in 1990] is only buyable if you've got somewhere to exhibit it. I was always in awe of Dia for making so many earthworks and site-specific installations possible; that is the exception – a collector whose significance survives. In short, sometimes you have to buy art that will have no value to anyone but you, because you like it and believe in it. The collector I have always admired most, Count Panza di Biumo, was commissioning large installations by Carl Andre, Donald Judd and Dan Flavin at a time when nobody but a few other oddballs like me were interested.

Richard Wilson, *20:50*, 1987
Used sump oil, steel. Dimensions variable.

You were born in Baghdad. What's your view on the war and the suffering of the Iraqi people since Bush and Blair decided to invade?

You were born in Baghdad. What's your view on the war and the suffering of the Iraqi people since Bush and Blair decided to invade?

Saddam was obviously a grisly psychopath, but there are so many vile butchers running bits of the world, why pick on him? Either kill them all, and let the CIA run the world, or leave the Saddams alone to torture and murder their own people. You choose. Just please don't say the UN, they never do anything but cluck.

Of the contemporary artists who died young – Jean Michel Basquiat, Eva Hesse, Felix Gonzalez-Torres – who do you think would have achieved long-term greatness?

Without being too callous, many artists achieve iconic status by dying before their work has a chance to dwindle into stale repetition.

So Pollock is revered for his masterpieces, and we will never see what he might have produced had he continued making art for another 30 years.

I have never really loved Basquiat's work, even though I was taken down to dealer Anina Nosei's basement where she had this young boy painting away there, telling everyone who'd listen that in young Basquiat she'd found a genius and for only $500 a picture. Silly me, I found it all derivative and decorative, so that shows how much my taste can be trusted.

Eva Hesse was fantastic. Felix Gonzalez-Torres was less so. Forgive my tackiness, but my favourite dead-artist-who-could-have-been-a-contender was Scott Burton. He did get a bit of recognition in the late 1970s with his quirky take on furniture as sculpture, and vice versa, and with his Rock Chairs formed by two sheer cuts into a boulder. Today he seems largely forgotten, except by a handful of fans who were around at the time, and it's quite rare to see him in surveys of key American artists. But that's what he was.

Excluding shows in your own gallery, what have been your favourite three exhibitions, either in a museum or commercial gallery, in the last 25 years?

I'm restricting myself to non-blockbusters, so no Picasso at MoMA in New York or El Greco at the National Gallery in London or the dozen other spectaculars I gratefully lapped up:

1. Clyfford Still at the Metropolitan Museum of Art, New York (November 1979–February 1980);

2. Jeff Koons at International With Monument Gallery, New York (December 1985);

3. Goldsmiths College MA degree show, London (July 1997).

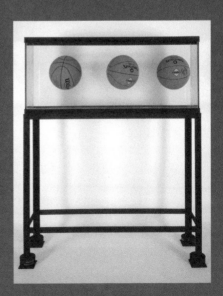

Jeff Koons, *Three Ball Total Equilibrium Tank (Two Dr. J. Silver Series, Spalding NBA Tip-Off)*, 1985, was exhibited at International With Monument Gallery in New York, his first show.

You've been successful at discovering new artistic talent. But are there not always great artists who go undiscovered?

You've been successful at discovering new artistic talent. But are there not always great artists who go undiscovered?

By and large talent is in such short supply, mediocrity can be taken for brilliance rather more than genius can go undiscovered.

Who are the artists you are most pleased with discovering?

Over the years I have been very lucky to see some great artists' work just at the start of their careers, so that I could feel 'pleased with discovering' them. However, I have also 'discovered' countless artists who nobody seemed to care much for but me and whose careers have progressed very slowly if at all. So I certainly don't have an infallible gift for spotting winners.

I think it's fair to say that I bought Cindy Sherman in her first exhibition in a group show, with some of her black and white film stills framed together in those days as a collage of ten images, and went on to buy much of her work for the next few years.

I bought most of the work from Jeff Koons's first exhibition in a small and now defunct artist-run gallery in New York's East Village, which included the basketballs floating in glass aquariums and the Hoovers and other appliances in fluorescent-lit vitrines.

But this is getting too self-congratulatory and the truth is I miss out on just as many good artists as I home in on.

Why don't you attend your own openings?

I don't go to other people's openings, so I extend the same courtesy to my own.

Do you think the UK press treats you unfairly?

No. If you can't take a good kicking, you shouldn't parade how much luckier you are than other people.

Do you want to be a celebrity?

I'm answering these questions, so I must be pretty desperate for something, but it certainly isn't celebrity.

On finding an artist that you love, do you set limits on the number of pieces from that artist you will buy (please make an assumption that budget is a factor, particularly as it means other options are then limited)?

There isn't a useful guideline I can think of. But a home full of the work of one favourite artist is often more interesting than a scatter-gun approach. Our house is usually full of Paula Rego pictures, but often as not it's just messy stacks of paintings I'm too lazy to hang, with empty walls and nails poking out when the Regos go off to some exhibition somewhere.

I'd happily pay good money to see the charred remains of your unfortunate warehouse on display in your gallery. Have you any plans in this regard?

I assure you that the art inside the warehouse was more fun to look at than the charred remains. But there's always a fire somewhere if you like looking at burnt-out buildings.

Were you surprised that the National Gallery of Australia chose to opt out of taking the 'Sensation' exhibition in 2000? How do you respond to the chief reason given for the cancellation, which was a serious concern about 'museum ethics' in the blurring of lines between public and private interests? The then-director, Brian Kennedy, even wrote an essay about museum ethics, to which he directed the attention of the media. Do you feel there was any question of ethics involved?

The National Gallery pulled out of 'Sensation' because it was causing a kerfuffle in New York at the time, and some of your fine local politicians decided to jump on the bandwagon. Brian Kennedy rolled over and who can blame him. Life's hard enough without looking to be a hero. But 'museum ethics' was just a feeble attempt to build a smoke screen. The central issue was the power of religious groups who it was feared would be enraged by a Black Madonna 'covered' in elephant dung.

A security guard, left, and a police officer kept watch over "The Holy Virgin Mary" yesterday, one day after a man smeared white paint on it. The painting, which has drawn protests, was quickly cleaned.

Have the post YBA generation of British artists got much to offer?

The YBAs represented a singular moment for British art, rather like the Beatles, the Rolling Stones and the Sex Pistols created break-throughs for British music. We are working on a show of new British art called 'Newspeak' for The State Hermitage Museum, St Petersburg, Russia [27 October 2009 to 17 January 2010]. It doesn't have the coarseness or brutality of much of the work from the 'Sensation' period, but there are quite a few good artists coming out of Britain right now, so I hope we produce a round-up that will finally stop people asking if British Art has been sat in a lay-by since the YBAs.

Did you personally burn, or did you contract with a professional arsonist to burn, your warehouse filled with your art?

It wasn't terrifically amusing the first time dull people came up with this. Now it's the 100th time.

What advice do you and your wife give to your children?

What advice do you and your wife give your children?

Nigella's mum gave her an invaluable insight into nice behaviour. According to Nigella her advice went something like this: 'It is better to be charmed than to charm.' By this she meant that what makes people feel good about themselves is feeling as if they have been charming, interesting; in short, have been listened to.

For her, the notion that one should oneself be riveting or aim to be quite the most fascinating person in the room was a vulgarity and just sheer, misplaced vanity. Trying to be charming is self-indulgent; allowing oneself to be charmed is simply good manners.

The concerns of an advertising executive centre upon novelty, immediacy of impact, and relevance to the target market. Many would say that these are the qualities that have characterised your collection. The concerns of the serious collector centre upon quality, the capacity to transcend time, high levels of skill and historical significance. To what degree do you feel these apparently divergent criteria to be in conflict?

The 'adman' theory is very appealing, very popular with commentators: But the snobbery of those who think an interest in art is the province of gentle souls of rarefied sensibility never fails to entertain.

Lord forbid that anyone in 'trade' should enter the hallowed portals of the aesthete. I liked working in advertising, but don't believe my taste in art, such as it is, was entirely formed by TV commercials. And I don't feel especially conflicted enjoying a Mantegna one day, a Carl Andre the next day and a student work the next.

What do you think about the great transition in the external aesthetics of museum architecture? Is it detracting from the art within or is it now necessary to attract a bigger audience? Do you think we are now seeing the end of the white cube as a gallery space, because of the nature of modern art?

The Arsenale in Venice

If art can't look good except in the antiseptic gallery spaces dictated by museum fashion of the last 25 years, then it condemns itself to a somewhat limited vocabulary. In any event it is often more interesting to see art in appropriated buildings like the Schaffhausen in Switzerland, or the Arsenale in Venice, or that remarkable edifice that hosted 'Zeitgeist' in Berlin. Buildings like these are flexible enough to display virtually anything an artist wants to make, and sometimes to better effect than somewhere swankily of-the-moment. So although a Bilbao or two is thrilling, there seems little point in spending millions on creating identical, austere Modernist palaces in every world city, rather than using the money to actually buy some art. But if you're looking for a 'destination' venue that will bring happy hordes to your city, Frank Gehry is probably pretty good value.

Blake Gopnik, the chief art critic for the *Washington Post,* has stated that 'painting is dead and has been dead for 40 years. If you want to be considered a serious contemporary artist, the only thing that you should be doing is video or manipulated photography.' Do you agree or disagree and why?

It's true that contemporary painting responds to the work of video makers and photographers. But it's also true that contemporary painting is influenced by music, writing, MTV, Picasso, Hollywood, newspapers, Old Masters. Unlike many of the art world heavy hitters and deep thinkers, I don't believe painting is middle-class and bourgeois, incapable of saying anything meaningful anymore, too impotent to hold much sway. For me, and for people with good eyes who actually enjoy looking at art, nothing is as uplifting as standing before a great painting, whether it was painted in 1505 or last Tuesday.

With your 'Triumph of Painting' show [2005], do you think you are setting a trend or following one? Haven't we all been here before with the 1981 show 'A New Spirit in Painting'?

You point out that 'A New Spirit in Painting' was nearly a quarter of a century ago. So I am tickled by your suggestion that another survey of painting now is over-egging it. I don't have a particularly lofty agenda with 'The Triumph of Painting'. People need to see some of the remarkable painting produced, and overlooked, in an age dominated by the attention given to video, installation and photographic art. Just flick through the catalogues of the mega shows, the Documentas, the Biennales, of the last 15 years. But, of course, much of the painting in our exhibition has itself been profoundly affected by the work of video and photographic art. In any event, who's to say what will one day appear to have been trendsetting? Sometimes artists who receive breathless acclaim initially seem to conk out. Other artists, who don't register so keenly at the time, prove to be trailblazers.

Are paintings a better investment than sharks in formaldehyde? The Hirst shark looks much more shrivelled now than it used to, but a Peter Doig canvas will still look great in ten years and will be much easier to restore.

There are no rules about investment. Sharks can be good. Artists' dung can be good. Oil on canvas can be good. There's a squad of conservators out there to look after anything an artist decides is art.

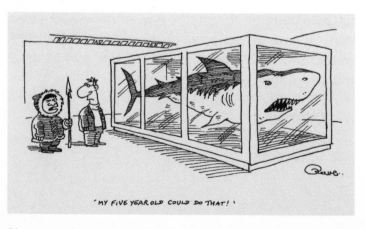

' MY FIVE YEAR OLD COULD DO THAT! '

At the top end of the art market, public and commercial spaces have become almost interchangeable. For example, at 'In-A-Gadda-Da-Vida', a show of new work by Damien Hirst, Sarah Lucas, and Angus Fairhurst at Tate Britain earlier this year [2004], most of the work on display was for sale and it came from just two dealers: Jay Jopling of White Cube and Sadie Coles. Do you see a conflict of interest in a publicly-funded museum being used as a sale room in this way?

I like everything that helps contemporary art reach a wider audience. However, sometimes a show is so dismal it puts people off. Many curators, and even the odd Turner Prize jury, produce shows that lack much visual appeal, wearing their oh-so-deep impenetrability like a badge of honour. They undermine all efforts to encourage more people to respond to new art.

So although I didn't adore 'In-A-Gadda-Da-Vida', it was nice to see something in the Tate that was fresh from the artist's studio. It helped make the Tate more relevant to today's artists. Of course the work had to come direct from the artists' dealers – it was brand new.

Anyway, what's wrong with Jay Jopling getting just a little richer?

How would you assess the Tate's performance as a museum of contemporary art?

Obviously the Tate Modern is a stupendous gift to Britain and Nicholas Serota [director of Tate] is my hero to have pulled it off so masterfully. I like some of the exhibitions at the Tate, but many are disappointing. The curators should visit more studios and grass roots shows. They evidently lack an adventurous curatorial ambition. And as for having outside curators called in to pick work at the Frieze art fair for the Tate collection... or to select the 'Triennial' Tate survey of new contemporary art...

It isn't enough to rely on the latest Turbine Hall installation and the Turner Prize to generate interest. The Tate seems sadly disengaged from the young British art community. It ought to have reflected the energy and diversity of British art over the last 15 years in both its exhibitions and collecting policy. Puzzlingly, museums in Europe and the US are far more interested in examining Britain's recent artistic achievements.

Why do overseas museums have better collections of Britart than the Tate?

Because the Tate curators didn't know what they were looking at during the early 1990s, when even the piddliest budget would have bought you many great works. But I'm no better. I regularly find myself waking up to art I passed by or simply ignored.

After your death, would you like to see the core of your collection kept together and remain on public view?

I don't buy art in order to leave a mark or to be remembered; clutching at immortality is of zero interest to anyone sane. I did offer my collection to Nicholas Serota at the Tate last year [2005]. This was about the time I was struggling with the problems at County Hall – both the alarming behaviour of the Japanese landlords and my failure to get a grip on how to use the space well. I remembered that at the time Tate Modern opened, Nick had told me that there were new extensions planned that would add half again to the gallery capacity. But by the time I offered the collection to Nick, the Tate already had commitments for the extension. So I lost my chance for a tastefully engraved plaque and a 21-gun salute. And now the mood has passed, and I'm happy not to have to visit Tate Modern, or its storage depot, to look at my art.

Looking ahead; in 100 years time, how do you think British art of the early 21st century will be regarded? Who are the great artists who will pass the test of time?

General art books dated 2105 will be as brutal about editing the late 20th century as they are about almost all other centuries. Every artist other than Jackson Pollock, Andy Warhol, Donald Judd and Damien Hirst will be a footnote.

Perhaps your greatest legacy will be that you, more than any other, have been responsible for pitching modern and contemporary art into the UK's cultural mainstream. Contemporary art is now discussed in taxis and government think tanks. Did you set out to achieve this from the start?

Yes.

What do you think of the art world?

What do you think of the art world?

David Sylvester [the late critic] and I used to play a silly little game. We used to ask ourselves, which of the following – artist, curator, dealer, collector or critic – we would least like to be stranded with on a desert island for a few years. Of course, we could easily bring to mind a repellent example in each category, and it made the selection ever-changing, depending on who we ran into that bored us most the previous week. Anyway, we pretty much agreed on the following:

Dealers

An occupational hazard of some of my art collector friends' infatuation with art is their encounters with a certain type of art dealer. Pompous, power-hungry and patronising, these doyens of good taste would seem to be better suited to manning the door of a night-club, approving who will be allowed through the velvet ropes. Their behaviour alienates many fledgling collectors from any real involvement with the artist's vision. These dealers like to feel that they 'control' the market. But, of course, by definition, once an artist has a vibrant market, it can't be controlled. For example, one prominent New York dealer recently said that he disapproved of the strong auction results, because it allowed collectors to jump the queue of his 'waiting list'. So instead of celebrating an artist's economic success, they feel castrated by any loss to their power base. And then there are visionary dealers, without whom many great artists of our century would have slipped by unheralded.

Critics

The art critics on some of Britain's newspapers could as easily have been assigned gardening or travel and been cheerfully employed for life. This is because many newspaper editors don't themselves have much time to study their 'Review' section, or have much interest in art. So we now enjoy the spectacle of critics swooning with delight about an artist's work when its respectability has been confirmed by consensus and a top-drawer show – the same artist's work that ten years earlier they ignored or ridiculed. They must live in dread of some mean sod bringing out their old cuttings. And when Matthew Collings, pin-up boy of TV art commentary, states that the loss of contemporary art in the Momart fire didn't matter all that much – 'these young artists can always produce more' – he tells you all you need to know about the perverse nature of some of those who mug a living as art critics. However, when a critic knows what she or he is looking at and writes revealingly about it, it's sublime.

Note: Since writing this I have got to know Matthew Colllings a little and like him a lot. So I wish I had picked on one of our other distinguished art critics to moan about.

Curators

With very few exceptions, the big-name globe-trotting international mega-event curators are too prone to curate clutching their PC guidebook in one hand and their Bluffer's Notes on art theory in the other. They seem to deliver the same type of *Groundhog Day* show, for the approval of 250 or so like-minded devotees. These dead-eyed, soulless exhibitions dominate the art landscape with their socio-political pretensions. The familiar grind of 1970s conceptualist retreads, the dry-as-dust photo and text panels, the production line of banal and impenetrable installations, the hushed and darkened rooms with their interchangeable flickering videos are the hallmarks of a decade of numbing right-on curatordom. The fact that in the last ten years only five of the 40 Turner Prize nominees have been painters tells you more about curators than about the state of painting today. But when you see something special, something inspired, you realise the debt we owe great curators and their unforgettable shows – literally unforgettable, because you remember every picture, every wall and every juxtaposition.

Note: Since writing this there have been 16 more Turner Prize nominees, of whom two have been painters.

Artists

If you study a great work of art, you'll probably find the artist was a kind of genius. And geniuses are different to you and me. So let's have no talk of temperamental, self-absorbed and petulant babies. Being a good artist is the toughest job you could pick, and you have to be a little nuts to take it on. I love them all.

Collectors

However suspect their motivation, however social-climbing their agenda, however vacuous their interest in decorating their walls, I am beguiled by the fact that rich folk everywhere now choose to collect contemporary art rather than racehorses, vintage cars, jewellery or yachts. Without them, the art world would be run by the State, in a utopian world of apparatchik-approved, Culture Ministry-sanctioned art. So if I had to choose between Mr and Mrs Goldfarb's choice of art or some bureaucrat who would otherwise be producing VAT forms, I'll take the Goldfarbs. Anyway, some collectors I've met are just plain delightful, bounding with enough energy and enthusiasm to brighten your day.

Count Panza di Biumo, the collector
I have always admired most.

What makes you laugh?

Do you think me glum because I always look cross in press photos? I'm sorry, it's just the way my face sets. But I always think that people with little sense of humour laugh most easily. Just sit in a theatre during a play critics call 'screamingly funny' and as soon as the curtain opens and the lead steps on to the stage set, pours himself a glass of whisky and coughs, the audience starts guffawing. They are there to have a good time and their happy laughter mode is on full-beam. I, sadly, often find the entire experience 'screamingly dull' and sit barely managing a thin smile. But Nigella is very funny, and we have a nice group of friends who all seem to be either journalists or comedians, so I do in fact spend a good deal of my life in giggling fits, honking away like a mad thing.

Your first wife is on record as saying that she only ever saw you reading comic books. Have you ever actually read a book? And if so, what was it?

Are you asking if I'm thick? I suppose I am rather, but that doesn't seem to hamper a career in advertising. And obviously, you can be as thick as a brick to buy art all day long.

Is it not just vulgar to spend ten times the value of an artwork just to make sure you get your hands on it?

It is very vulgar, and I wish I had a more genteel, and cheaper, way of getting the pictures I want. But they are usually owned by very rich people who are often greedy.

What's the point of art?

To stop our eyeballs going into meltdown from all the rubbish TV and films we happily look at the rest of the time.

If you were commissioning your own portrait, in which medium would you choose to be represented?

I'd rather eat the canvas than have someone paint me on it.

Can you tell me anything about yourself that might make me like you?

But why would I care whether you like me?

Why has Damien Hirst lost his inspiration?

He is a deeply gifted artist, a genius among us, but he's had a bad run of shows over the past few years. All great artists have an off patch, and he's having his. Usually when that happens, artists try too hard and the results look effortful and overblown. But I'm sure his next show will be a winner.

What is it like being married to the most desirable woman on the planet?

Unbelievable – literally. Women are all a little deranged, everybody knows that, but why Nigella would wish to be with me is beyond human understanding. My bleating gratitude perhaps; surely the world's most effective aphrodisiac.

Damien Hirst called you an art shopaholic. Was he right?

Too right.

Duane Hanson, *Young Shopper*, 1973
Polyester and fibreglass, polychromed in oil,
with accessories, life size

Does refurbishing Damien Hirst's rotting shark rob it of its meaning as art?

Completely.

Is London still at the cutting edge of world art?

Yes it is. London is alone in breeding artists who organise their own alternative exhibitions in temporary spaces they commandeer – empty factories, offices, shops – and beat the dealers at showing the freshest art around. There are so many galleries in New York, it's probably easier for artists there to find dealers prepared to show new work by unknowns.

Are you really hoping to find the next Emin or Hirst when – as you recently said – you hunt for art in grotty parts of London at weekends?

If you don't live in hope, why get up of a morning? Is a dashed hope better than no hope? Must I always answer a question with a question?

Is there an art critic who can make or break an artist's show, rather like Frank Rich, the celebrated theatre critic in New York, who had the reputation of being able to make a production close overnight with an unfavourable review?

People tell me that a Roberta Smith review in the *New York Times* carries some weight, but that's because it's the only paper in town. Ms Smith has been looking at art as hard and as long as anyone, so she mostly knows what she is seeing (not too patronising I hope, Roberta). But, in reality Americans believe the *New York Times* is created each day by God and its sonorous tone accords it absolute authority. So with rich New Yorkers being notoriously insecure about their art collecting, a respectful review offers great reassurance. Or so I thought.

It seems that in recent years the main driving force for much collecting has been the giddy rush to board the gravy train as prices for contemporary art rocket ever higher. The critics don't get a look-in anymore.

With your former adman's hat on for a moment, would you say that David Cameron has the X factor?

I'd rather have Simon Cowell.

The artist Peter Blake has called you a 'malign influence' because of the way you can 'make' certain artists. Are you a malign influence?

The artist Peter Blake has called you a 'malign influence' because of the way you can 'make' certain artists. Are you a malign influence?

I wonder whether Peter Blake would consider me a less malign influence if I had bought some of his art. I try not to chew my nails down to the quick worrying about everything I do, otherwise I'd end up doing nothing.

Should the country be spending money on saving Old Masters for the nation, or buying up works by the next generation of artists?

At the risk of being lynched – again – by the art crowd, I don't think there is a great need any more to save paintings for the nation at the cost of supporting new art. What difference does it make if a Titian is hanging in the National Gallery, the Louvre or the Uffizi?

This isn't the 18th century: people travel, so there's no need to be nationalistic about the world's art treasures. Much more important is to back living artists.

Is there any artist you regret failing to snap up before they became famous?

Vermeer, Velazquez, Van Gogh.
And that's just the Vs.

What is your favourite museum in the world?

The Prado in Madrid.

I have a weakness for Goya, but the museum itself is so unfussy, and clearly loves to display its many masterpieces as unshowily as possible, each visit reinforces my belief in the enduring importance of art.

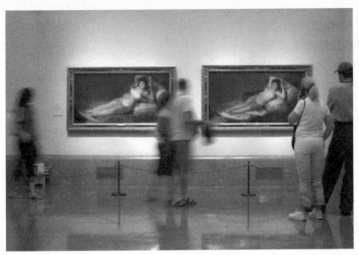

Prado Museum, Madrid

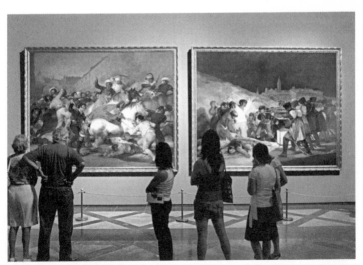

Prado Museum, Madrid

81

What's the idea behind letting any artist put their work up on the Saatchi gallery website? You exercise no quality control and surely visitors to the site would prefer to see a selection of artists that have been edited and filtered by you or your team to weed out work lacking in real quality.

The great majority of artists around the world don't have dealers to represent or show their work. It makes it pretty well impossible to get your efforts seen, with most dealers too busy or too lazy to visit studios – and who can blame them. They have probably become a bit disenchanted by seeing acres of slides and transparencies of tragic work foist upon them by desperate artists. In reality, most dealers find new artists to show through recommendations from their existing stable – artists often urge their dealers to look favourably upon the work of their friends; furthermore, dealers usually believe artists are good judges of other artists' work. All in all then, if you're not in the right artistic social circles, didn't go to a hip art school, don't quite fit in, it can be hell to extract much interest from dealers and collectors.

By allowing artists unfettered access to create their own pages to present the work free on the site, communicate with other artists, sell their work without commission direct to buyers, we want to break this deadlock.

Personally, I am overwhelmed with pleasure at seeing the site now used as a showcase by over 120,000 artists. I used to feel a little depressed whenever I visited an artist in one of those buildings housing 50 or so artists' studios, knowing that 49 of those artists would rarely get a visitor of much help to their careers.

The site is helping to get lots of artists' work out of their studios and onto collectors' walls. It's thrilling, and I wish it had happened earlier

The visual arts leave me cold. I just don't get it. Where am I going wrong?

The visual arts leave me cold. I just don't get it. Where am I going wrong?

Don't fret about it. I don't care about ballet leaving me cold. Or most films. Or nearly all theatre. There aren't enough hours in the day for all the things we do love to do, without looking for ways to force-feed yourself something that you just don't respond to.

Caroline Gold, *Ballerina I*

Your 'USA Today' show [2006] caused a fuss because of works like Terence Koh's Peeing Madonna. Why do you rate work with this kind of offensive shock value as 'exciting'?

Many of the artists who we see in the National Gallery or the Louvre or the Uffizi were considered offensive or shocking once. I like all kinds of art, some of which is pretty boorish I grant you, but please be my guest at 'USA Today', and leave me a note if you think that anything there is truly more tasteless than so much we see around us every day.

What's wrong with the new generation emerging from British art schools?

What's wrong are the art schools. In Britain our art schools are, of course, under-funded. They therefore have to take on too many students from abroad with poor skills but rich parents who can afford the higher fees for overseas students, helping the schools' budgets but leaving talented, but impecunious, students without a look-in. In the era that created the YBAs, a brilliant crop of students came together with a wonderful group of teachers and that union created something memorable. The only memorable thing about art schools now is how forgettable the students' work invariably is. One has to marvel how much the spirit of confidence in our art schools has been sapped in just a few years.

Note: This sounds more depressing than it should. I still like going to the Degree shows, and have found good new artists in recent years at the Royal Academy School, Chelsea School of Art and the Royal College Sculpture School.

Is it true you had to remove Tracey Emin's 'My Bed' from your house because of the smell, and that someone turned off Marc Quinn's 'Self' refrigeration causing the frozen blood to melt?

No.

What is the nature of the relationship between you and the artists?

I don't buy art to ingratiate myself with artists or socialise in the art world. Most of the artists I meet are rather like everybody else you meet: some are nicer than others.

Do you ever buy art you admire technically, and in which you see some future value, but don't actually like?

No.

How do you rate political advertising today?

How do you rate political advertising today?

Dim, unsubtle and charmless ever since I stopped doing it, he answered modestly.

You don't go to openings or parties and rarely give interviews. Why is a man with such a flair for publicity so reclusive?

I'm just a cocktail party dud, I'm afraid, and am lost in admiration for friends who are at ease walking into a roomful of people, and chatting happily as they work the room. I would do more interviews but I think I am too sensitive (definition: vain and touchy).

I keep reading that your 'Neurotic Realism' show [1998] was your most famous flop. Why was it such a failure?

I bore myself to a stupor in a self-pitying whinge about good shows that get caned, or worse, overlooked (like our final show at Boundary Road of the eviscerating work by the Russian photographer Boris Mikhailov, that got absolutely no reviews and about four visitors).

So the truth is, even a thorough shredding of an exhibition means that at least the critics have been kind enough to cover it, if only to cover it in bile.

'Neurotic Realism' was a critical failure of my own making, caused by giving it a title that whiffed of an over-arching effort to create a new art movement, rather than a feeble attempt to find a catchy show title. But in some defence, the exhibition did introduce the work of Ron Mueck, Noble & Webster, Cecily Brown, Dexter Dalwood, Martin Maloney, Michael Raedecker, all of whom went on to international acclaim.

If I hadn't come up with such a clunker of a name, they would probably have got more favourable attention at the time, rather than having my own poor judgement get in the way.

You created Saatchi & Saatchi, which grew to become the world's biggest ad agency in the 1980s. Does the TV programme *Mad Men* capture the world of advertising accurately?

What I adored most about my advertising agency was the fanatical devotion to keeping our clients happy, our desperate longing to have our campaigns succeed for them, and to win as many big accounts as possible. We were maniacally driven to impress our clientele, and if all other businesses cared as much about providing satisfaction as ad agencies, we would have no need for automated Customer Service Helplines everywhere.

I recommend advertising to all, especially if you have no apparent academic skills. It's easy money, and whatever small abilities you have can be put to good use somewhere in an ad agency, whether it's your charm and wit for client hand-holding, technical talents suited to the complex world of media buying, or if you must, writing slogans and soundbites for power-hungry politicians. *Mad Men* seems to move at a snail's pace but its evocation of the early 1960s is very nicely done. It bears no resemblance to any second that I have ever spent in advertising.

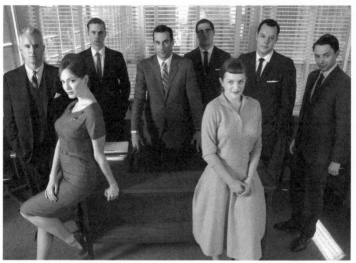

Main cast of drama series *Mad Men*

Do you think art fairs are a good thing? Are they good for Artists? Collectors? Dealers?

I don't go to the Basel Art Fair anymore, which I used to enjoy greatly. Now I can no longer escape the feeling that the booths in the Basel Art Fair, so full of glossy art, will be full again for the next Fair in their calendar with shiny agricultural implements in the Basel Farmers' Fair, or in the fair after that with medical supplies in the Basel Pharmacists' Fair. It just made me feel a little sheepish about being an art collector. But I've always believed that it is important for artists never to be allowed near an art fair for fear that the disillusionment with being part of a meat market would traumatise them into abandoning their brushes.

As a general rule are art critics all failed artists, and dismissed as such?

In the UK we have so many newspapers carrying lengthy art reviews that most shows find themselves getting a mixed bag of responses, and no one critic matters that much, whatever their credentials. My favourite, Brian Sewell, has never written a favourable word about any show I've done in 20 years, but dismisses them with such grandeur and style, it's almost flattering to be duffed up by him. The days when critics could create an art movement by declaring the birth of 'Abstract Expressionism', Clement Greenberg-style, are firmly over.

By the way, there is no such thing as a failed artist.

Can you paint or draw yourself?

Not even a little bit.

I know
very little
about
contemporary
art but
have £1,000
to invest.
Any advice?

I know very little about contemporary art but have £1,000 to invest. Any advice?

Premium bonds. Art is no investment unless you get very, very lucky, and can beat the professionals at their game. Just buy something you really like that will give you a thousand pounds' worth of pleasure over the years. And take your time looking for something really special, because looking is half the fun.

How do you feel about art that you have bought that turns out to be worthless, or worth much less than you have paid for it?

How to answer this question with total transparency...

OK, it's very handy if the art you buy goes up dramatically in value. But there is something equally satisfying in feeling that you have appreciated work that nobody else quite gets, and aren't you a cleverclogs for spotting it.

Will that do?

When you first started art collecting, was it just to decorate your home?

Yes and No. I had a few bits and pieces and hung them on the walls, but once you have bought something that doesn't fit in your home, and has to be stored in an art depot, you're officially an art collector.

Who are your living heroes?

Gregory Peck in *To Kill a Mockingbird*. Marlon Brando in *On the Waterfront*. Cary Grant in *North by Northwest*. Burt Lancaster in *Sweet Smell of Success*. Gary Cooper in *High Noon*. They live forever, if you grew up in the local Rialto.

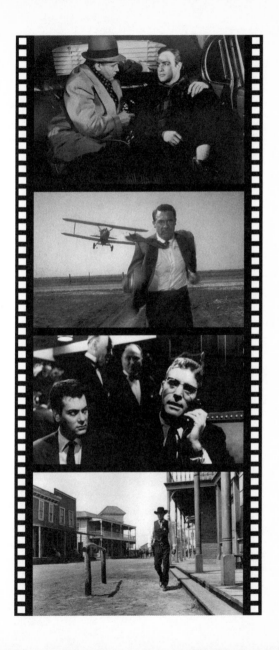

Why a show of Chinese art [2008]?

If China's economy keeps growing as it has, our children will all be speaking Chinese in 50 years' time. When I first looked at the new Chinese art, I thought it was horrible, and most art that looks horrible at first stays looking horrible. Occasionally, though, the really awful ones nag at you to go back for a second and third look, and they worm away until you finally get it.

When we checked the automated Chinese translation on our website for the '*New Art From China*' exhibition, it read as '*New Art From Porcelain*'. So we had no choice but to get thousands of pages translated into Chinese by hand.

Why now?

Now that I have the zeal of the newly converted, I feel compelled to proselytize.

Why the long wait for your new gallery to open?

Try the Considerate Builders Hotline 0800 783 1423

Is the 'New Art From China' exhibition about Saatchi the collector, or Saatchi the salesman?

It's about the art, stupid.

What's the difference between you and Lord Elgin? Aren't you stripping the Chinese of their rightful artistic heritage?

No offence to the Greeks, but I think the Chinese are big enough to look after themselves.

Do you believe in it all?

I am not clever enough to be a cynic, so belief is the only option available to me.

Is there not a paradox somewhere? How can you be so shy and yet so voluble?

I am neither shy nor voluble. I don't like going to parties, but I do like showing off my art. I am quite comfortable with my schizophrenia.

What would you want on your epitaph? In what terms do you think of your legacy?

Just how dull do you think I am? What kind of twat is interested in epitaphs or legacies?

What's Nigella's cooking really like?

I'm sure it's fantastic, but a bit wasted on me. I like toast with Dairylea, followed by Weetabix for supper. It drives her to distraction, frankly, particularly as she gets the blame for my new fat look. But the children love her cooking, and our friends seem to look forward to it.

Did you cringe for your wife when you watched her terrible chat show?

Nigella owed somebody a favour and repaid it in full with that show. But what's not to like? I and a few million other Nigella fans enjoyed it anyway because we could happily stare at her all day.

Have you ever taken advantage of anyone in the art world?

Have you ever taken advantage of anyone in the art world?

If you asked the Dalai Lama, Mother Teresa or Mahatma Gandhi if they had ever taken advantage of anyone, they would be lying if they claimed they hadn't. So you can put me right up there with them, thanks.

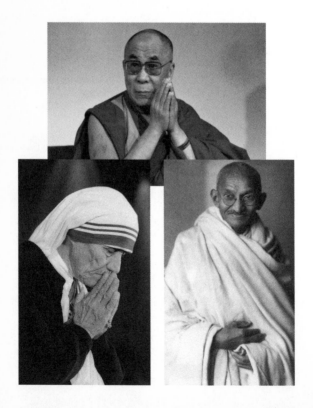

What is your proudest achievement?

I don't do pride. That's not to say I don't have an ego the size of an aircraft hangar, but I'm not even very proud of that.

Do you feel responsible for the British art scene as we know it?

No.

Is ego a part of that?

I don't seem to have given you the answer you wanted above. Sorry.

What do you buy apart from art?

I have a shocking Frappuccino habit, so what doesn't go on art goes to Starbucks.

What is the one thing you now really wish you could buy?

My way into Heaven.

What keeps you going?

What's the alternative?

Do you still care about money?

I have never cared enough about money to worry about spending it, and have been fortunate to make enough to be spoiled rotten.

Do you care what people think?

Everyone cares what some people think, but luckily I seem to care less than most.

Professionally, what was your greatest mistake?

That is a really depressing question. I have made so many mistakes, and such really stupid ones, I would start blubbing away if I could remember even half of them. But do not dwell on cock-ups, I say. You don't learn by your mistakes – at least I don't – so best to blunder on making fresh ones.

Any ambitions left?

Maybe I'm just not a checklist kind of person.

Of which artist are you most proud?

Of which artist are you most proud?

How can I feel proud about an artist's work? I didn't have the idea, and I didn't make the art. There's no pride to be had by simply buying it.

What are your thoughts on the rise of the artist as celebrity?

Better to be a celebrity because people talk about your art, rather than your wedding photos in *Hello!*

Have you distorted the market by being such an influential buyer?

I have been asked this question before, and I still haven't got to grips with it. I always thought that what people bought and sold was by definition 'the market'.

What do you have in your bedroom at home?

I have that Nigella.

What do you like about the 'old geezers' piece in the show by Sun Yuan and Peng Yu?

I'm rather looking forward to my wheelchair years. Nigella has already fixed me up with caring Wife No. 4 to push me about and wipe the drool, and brutal Wife No. 5 to make me welcome death gratefully.

How do you decide where to put each work?

No subtlety here. I just go by what shapes and colours work together in a room. Occasionally I try putting things together that have a meaningful 'link', and then back off quickly. The poncy way some curators try to demonstrate their 'vision' by highlighting connections gives me the colly-wobbles.

What is your favourite piece in your collection at the moment?

I don't play Art Olympics. I don't have a Top Ten artists or a Top Ten favourite works bobbing around in my head.

After the semen paintings displayed in your 2006 show 'USA Today' – is there anything you wouldn't show at Saatchi?

Anything I don't like.

Are you comfortable with Liu Wei's 'Indigestion II'?

I don't think the artist intended people to feel comfortable looking at a giant poo. He's not an interior decorator.

What did you pay for it?

I've thankfully blanked that from my memory.

Liu Wei, *Indigestion II*, 2004 – 2005
Mixed media, 83 × 214 × 89 cm (32³/₄ × 84¹/₄ × 35 in)

**Are you going to the private view?
If not, why not?**

What for? I've already seen the show.

Saatchi Online features the work of tens of thousands of artists. How much of this is dross and how would the user identify the dross?

They're as good and as bad as you would see on any tour of contemporary galleries. People are perfectly capable of deciding for themselves what they like or don't. And it's a lot less intimidating looking around online than having some creepy gallery person patronising you.

You famously created the slogan 'Labour isn't Working'. Were you a Tory? Are you a Tory?

You famously created the slogan 'Labour isn't Working'. Were you a Tory? Are you a Tory?

I once also threw myself into the Health Department's Anti-Smoking campaign, visited emphysema wards, studied pictures of cancerous lungs, and came up with the grisliest copy I could – puffing away happily as I wrote. How sweet of you to think that advertising copy is written from the heart.

Some of the art in the 'New Art From China' exhibition [2008] seems a bit derivative of the YBA heyday – what is so special about it?

You've obviously spotted something I hadn't. And what's more, even now you've pointed it out, I still don't see anything YBA-ish about it.

What do you say to those who say we should have nothing to do with Chinese art – on grounds of the country's appalling human rights record?

Oh, please.

Have you got any Chinese stuff at home?

What's with the 'stuff'? This is art, mate.

After China, what next? Can you envisage an Islamic show?

Funny you should say that. I'm working on a show for 2009 called 'Unveiled', featuring art from the Middle East. What I've found so far from Iran and Iraq is encouraging.

Your old space at County Hall was much maligned. Will the same happen at your new gallery in Chelsea?

Of course.

Note: A recent review described it as "the White Elephant of the King's Road, filled with trash".

Isn't Chelsea all a bit too 'establishment'? Will the Hoorays and the rugger-buggers get it?

I don't go in for snobbery. I leave that to journalists.

Why do you use such an antiquated mobile phone?

It's the only one I can work.

Has photography rendered figurative art pointless?

No art is pointless. I had that Immanuel Kant round for a bit of a chin-wag the other day and he told me that the meaning of art was that it had no function.

Kant

Is painting dead?

Yawn.

Should children be taught traditional drawing in schools or encouraged to be creative?

Both.

What do you think of other television shows about art such as those presented by Sister Wendy Beckett and Rolf Harris?

I'm ashamed to say I've never seen either.

When you express interest in an artist, the art world takes immediate notice. The result is a rise in prices. Do you ever try to buy works anonymously to prevent this from happening?

No.

What do you think of the Prince Charles school of art?

I don't.

How much money have you lost in the recession?

I daren't look.

How do you decide whether something is worth £10 or £10 million?

It's not up to me to decide how much something is worth. People can ask what they like and I either put up or shut up.

Are the National Gallery and the Tate too conservative? If you had to choose would you be happier to see Tate Modern or Tate Britain burned down?

I spend much of my life in the National Gallery and the Tate, so excuse me if I don't take your question too seriously.

Did your activities make London the centre of contemporary art?

London is not the centre of contemporary art.

What about Manchester? Could it happen anywhere else?

Not Manchester, I think. But they do football pretty well.

Why is Jackson Pollock your favourite 20th century artist?

1. *One (Number 31)*, 1950, Museum of Modern Art, New York
2. *Autumn Rhythm (Number 30)*, 1950, Metropolitan Museum, New York
3. *Lavender Mist (Number 1)*, 1950, National Gallery of Art, Washington
4. *Blue Poles (Number 11)*, 1952, National Gallery of Australia
5. *Out of the Web: (Number 7)*, 1949, Staatsgalerie Stuttgart, Germany
6. *Convergence*, 1952, Albright-Knox Art Gallery, New York
7. *Lucifer*, 1947, San Francisco Museum
8. *Eyes in the Heat*, 1946, Peggy Guggenheim Collection, Venice

Why have you agreed to host a television show?

'Hosting' is a bit grand. I don't appear on the show ['Saatchi Art Stars' (title tbc), BBC TV, October 2009] or talk. Sadly, I don't have Simon Cowell's looks or charm, so it's best if I don't push my luck.

Are you trying to educate or entertain?

If the programme is a dull flop, I'll pretend it was intended to educate. But obviously it would be nicer if it were entertaining enough to draw people to contemporary art.

How much television do you watch and do you prefer *Big Brother* or *Newsnight*?

I watch hours of television. My favourites are *University Challenge* and *Match of the Day* and almost anything on the ironically named Living channel. *Big Brother* is out of the question, even for me.

How would you rebrand Gordon Brown?

His brand is flawless in its clarity, just like Kellogg's All Bran. You know exactly what you're going to get with Gordon Brown.

Why do you hate glib little questionnaires which ask you intrusive questions about your personal habits and marriage?

I'm doing it, aren't I?

When are you giving up the cigarettes?

No doubt that's the first thing Wife No. 5 will make sure I do (see Old Geezers question on page 117).

What does Nigella think of your addiction?

She loves every little thing about me. Why do you ask?

Do you think you have messed up anybody's life by flogging off all their work?

Do you think you have messed up anybody's life by flogging off all their work?

I don't buy art just to make artists happy, any more than I want to make them sad if I sell their work. Don't you think you're being a bit melodramatic?

What has been your biggest mistake in what you have bought?

There's stiff competition, but fortunately I have a very poor memory, so although I've made many mistakes, I'm never haunted by them.

Does it matter that many pieces are now made by assistants rather than the artists themselves?

Like what that Rembrandt and Rubens done, you mean?

If you could wish any work of art in the world into your collection what would it be?

It would be whatever I bought today that I'm mad with excitement about.

Who is the next big artist?

That's what the TV show will discover, we're hoping.

Did *For the Love of God*, Damien Hirst's diamond-encrusted skull, symbolise the emptiness of modern art – more about money than message?

My dear, the money is the message.

I have a small collection of well known British artists of the 1950s and 1960s – they don't seem to go up in value very much, so would I do better to sell them and start again with artists who are more current and more likely to grow in value?

I am the wrong person to ask. I believe in buying new young artists, so kiss goodbye to your elderly Brits, and throw yourself headlong into the pleasures of building yourself a new collection. But unless you really know what you're doing or get very good advice, or very lucky, your new collection may not grow much in value either.

Is too much art now about shock value rather than creativity, like Tracey Emin's unmade bed?

Is too much art now about shock value rather than creativity, like Tracey Emin's unmade bed?

Some people like the art, some people like being shocked by it. Everyone's happy.

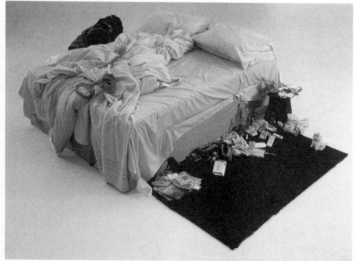

Tracey Emin's Bed

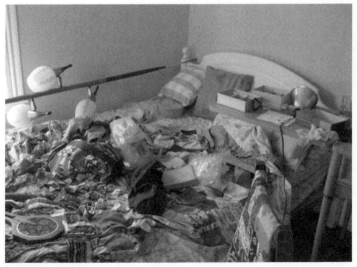

Someone else's bed

Aren't those dot paintings just like wallpaper?

You may as well say that Rothko paintings look like nice rugs. There's no crime in art being decorative.

Aren't the titles of so many works of art just too pretentious?

So much of the art world is pretentious, why pick on artists' silly titles?

Do you own anything that is over 50 years old?

Me.

What will survive from the late 20th and early 21st century?

Art history books can be very cruel in their editing, so something published in 200 years' time will leave out a lot of the people we think of as terribly important.

Is elephant dung as valid a medium as gouache?

Elephant dung is so last season, darling.

Were you surprised by the amount Damien Hirst made at his auction? Was that the tipping point?

Surprised doesn't begin to cover it, but I'm very happy for Damien.

Is the story about Marc Quinn's head being made from frozen blood melting in your freezer true?

It was such a good story, I felt obliged to confirm that it was true and managed to convince myself it was. But actually, it's not.

What are your favourite shopping luxuries?

I love Selfridges and Starbucks, but art is my only extravagance.

Why did you switch from advertising to art?

I started collecting art before I went into advertising. And anyway, advertising is for the young, bright-eyed and bushy-tailed.

Are dealers artificially inflating prices – e.g. Jay Jopling at 'Beautiful Inside My Head Forever'?

How do you artificially inflate prices? People either want to buy it or they don't.

Is the Government too conservative in the way it supports the arts? What should the Culture Department be spending money on?

I wish I had the interest to answer.

Nigella once said it was bad for children to inherit wealth. Will you leave any money to your children?

Yes. I spoil my children rotten and hope to leave them enough so they can do the same to theirs.

Is it true that you went on a diet that involved eating nine eggs a day? Did it work?

Yes, it's true. I was fat and ugly and now I'm thin and ugly.

Are you a computer techy? You seem to be obsessed with your gallery website?

I am extremely un-techy. But even I can use a finger to Google.

Do you feel more British, Jewish or Iraqi?

Yes, the delightful Norman Tebbit question — who would I cheer for if England were playing Iraq at cricket? Iraq, of course, alongside everyone else who enjoys a good laugh.

Someone once described you as a 'man of crushes'. What or who do you have crushes on at the moment?

According to my friends, my real and unwavering crush is on myself.

What is it like being married to a domestic goddess?

She's too good for me, I know, but she knows it too and reminds me every day.

What is your favourite Nigella Lawson recipe?

Nigella Lawson.

Do you ever do the cooking?

I can do eggs. And cornflakes.

Were the children ever allowed ugly plastic toys?

When they were young, I adored seeing my children playing with My Little Pony, Lego and even Barbie. Now they're teenagers I would rather not think about what they play with.

Do you encourage your children to look at your art and go to museums and galleries?

My children think it's very uncool to have anything to do with my gallery. But they quite like the gallery shop.

HEALTH
AND
EFFICIENCY

JULY :: 1955
ONE SHILLING

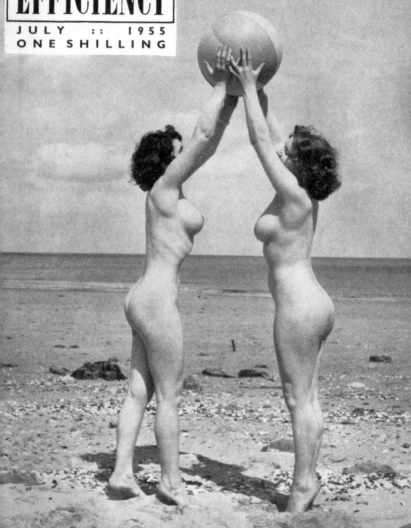

THE WORLD'S LEADING NATURIST JOURNAL Est. 19

What did you collect as a child?

I had a first-rate collection of *Health and Efficiency*, the nudist magazine that was around before there was such a thing as a top shelf at your newsagent, but my mum found them, gave me a slap and bunged them.

How can you tell a good Picasso from a bad Picasso? Come to that, how can you tell a good Damien Hirst from a bad Damien Hirst?

How can you tell a good Picasso from a bad Picasso? Come to that, how can you tell a good Damien Hirst from a bad Damien Hirst?

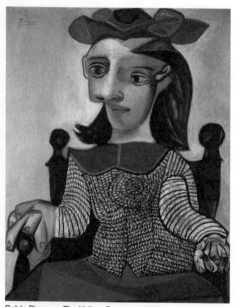

Pablo Picasso, *The Yellow Sweater*, 1939
Oil on canvas, 81 × 65 cm (31⅞ × 25⅝ in)

If you can't tell a good Picasso from a weak one or a good Hirst from a lazy one, your collecting days are going to provide you limited satisfaction. That is, after all the whole pleasure of choosing your art. The key is to have very wobbly taste, like me, so that although I know the Picasso on the left is a beauty, a real jewel that would grace any mantelpiece, I have an equally soft spot for the bizarre but so effortless and confident picture on the right.

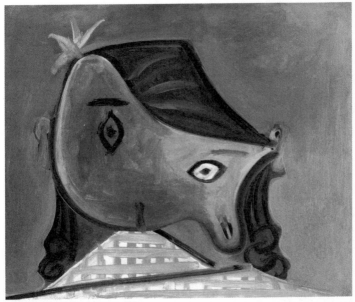

Pablo Picasso, *Tête de femme*, 1939
Oil on canvas, 33 × 41 cm (13 × 16 1/8 in)

Alfred Hitchcock or John Ford? Scorsese or Spielberg?

I am ever thankful for seeing these directors' best work. Nigella and I hold little film festivals at home for ourselves, with a William Wyler, Ridley Scott or Fred Zinnemann season, and the great directors have me awestruck over each frame.

Alfred Hitchcock's *Vertigo*

John Ford's *The Searchers*

Martin Scorsese's *Raging Bull*

Steven Spielberg's *Raiders of the Lost Ark*

What was the first record you ever bought?

I can't remember if it was Sanford Clark's 'The Fool' or 'Reet Petite' by Jackie Wilson, in 1957. 'The Fool' was your basic rockabilly three-chord number with an exceptionally deep echo chamber and an insistent guitar theme running hypnotically throughout. Sanford Clark was a one-hit wonder, who had dreams of becoming Elvis. I loved it, but it was no 'Mystery Train', my favourite Presley record of the time and probably ever.

I spent every second I could tuned into AFN (American Forces Network) on the radio, listening to the music coming out of America from about 1955 – Fats Domino, Bo Diddley – and remember the ecstasy of first hearing 'Maybelline' by Chuck Berry as it headed up the US charts.

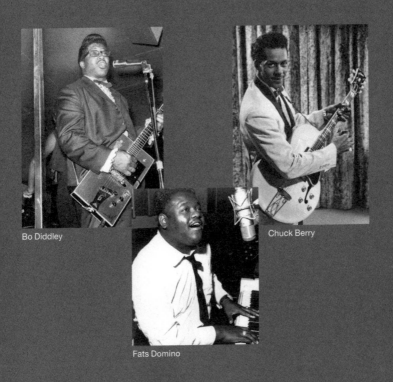

Bo Diddley

Chuck Berry

Fats Domino

'Reet Petite' was written by Berry Gordy, what a guy, who went on to found Motown records. It became a big hit in Britain 29 years later, thanks to being featured in a Levi's commercial, bless them.

Why do you have no video art in your collection?

I have a little, but it's been very hard for video makers to move much beyond the work of the great pioneers of video like Nauman, Warhol, Vito Acconci, Joan Jonas etc... The thrill of video as a new art medium wore off for me about 20 years ago and I find it hard to get over-excited by what I see. Particularly since I see very little, as I furtively slope past darkened rooms in galleries. I should feel guilty about such idleness, as a supposed art lover, but I think I have been punished enough by hours of self-indulgent flickerings. Even video God Matthew Barney looks a bit MTV to me.

Do you like the big international block-busters like Documenta and the Venice Biennale?

I haven't been to Documenta in years. Sometimes I go to Venice because Venice is a lot easier on the eye than Kassel [The German hometown of Documenta]. Documenta used to be pretty good but has been taken over since about 1990 by curators who like to wear their 'intellectualism' very heavily, the silly bores. Venice is less samey because individual nations get to pick their own favorites in the national pavilions – usually all terrible, but quite entertaining. However the central curated 'Biennale' shows are a bit of a slog – acres of politically charged but visually flaccid work with much too little in the way of standouts.

Which art dealers do you like?
Which ones don't you like?

Leo Castelli

Leo Castelli was the nicest and brightest of contemporary dealers, an elegant and urbane gent who discovered Johns, Rauschenberg and Warhol and gave many artists their first break.

He was very kind to me when I was just a soppy art groupie, helped me get many great works over the years, and his enthusiasm inspired me to start my first gallery at Boundary Road.

I adore Larry Gagosian, but I always hear the theme music from *Jaws* playing in my head as he approaches. He is clearly the most successful art dealer of the last couple of decades and his beautiful and well-installed shows have finally earned him the respect of a grudging art world.

In fact, the list of dealers I like is quite lengthy – they're helpful and try to make sure I get the work I want. The list of dealers I dislike is also quite lengthy. Art attracts about the same percentage of horrible people as any business full of big money and bigger egos.

How do you know if something is worth £1,000 or £10,000 if it is by an unknown artist?

How do you know if something is worth £1,000 or £10,000 if it is by an unknown artist?

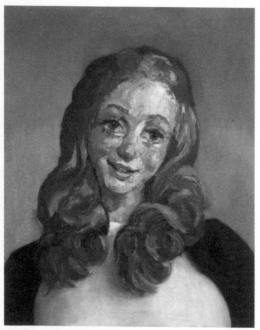

John Currin, *The Optimist*, 1996
Oil on canvas, 81 × 66 cm (32 × 26 in)
Price sold: US $433,600

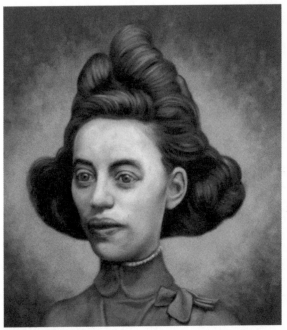

Richard Moon, *Felixia*, 2007
Oil on canvas, 76 × 66 cm (30 × 26 in)
Price sold: £3,500

You could ask 99% of people why one of these recent paintings sold for £3,500 and the other for $433,600. They wouldn't know.

You could ask 99% of people in the art world the same question, and they wouldn't know either. Of course, they *would* know that the painting on the left is by John Currin, much respected American artist, in all the right museums and top collections, even shown at the superb Saatchi Gallery in 1997 (his work was of course ignored or derided by most of the eagle-eyed art critics at the time, though they all learned to admire him greatly when it became fashionable to do so a few years later. Not that I'm chippy or anything).

The other painter Richard Moon is British and largely unknown, whose work I saw at his Royal Academy School degree show.

If The Fates had given Moon the right contacts, got him into the right gallery, had them place his work in the right collections and shows, then switched him to the world's most powerful dealer to launch him to superstardom, as The Fates did with Currin, the sales figures might be reversed. Now I'm not saying that Currin isn't an outstanding artist. He clearly deserves all his success, and is probably an infinitely more interesting painter than Moon. But believe me, talent alone is no guarantee of success, or explanation as to why some mediocre artists become burningly popular

for a while, whilst better artists languish waiting for a call that never comes.

I am an art curator who has worked on a number of well known exhibitions at museums and international biennale art surveys. I have created a mental exhibition of works drawn from Saatchi Gallery shows since you opened in 1985. What do you think of my enclosed list?

You chose Andy Warhol's giant diptych *Blue Electric Chair*, his greatest ever painting.

You chose Cy Twombly's *Sahara*, my favourite painting of his.

You chose Donald Judd's *Copper Box with Red Base*. Perfect.

You chose Brice Marden's *Red Yellow Blue*. Perfect.

You chose Philip Guston's *Painter in Bed*. Perfect.

You chose Jeff Koons's *Rabbit*. Who wouldn't?

You chose Richard Serra's *One Ten Prop*. Perfect.

You chose Charles Ray's *9ft tall Executive Woman*. Agreed.

You chose the Chapman Brother's *Hell*. So would I, if it hadn't itself gone to hell in the Momart fire.

All in all, a lovely little group show, that would bring a tear to my rheumy eyes.

So much contemporary art all looks the same to me. Am I missing something?

So much contemporary art all looks the same to me. Am I missing something?

Plagiarism, whether conscious or unconscious is always going to be an obstacle course. Look at these:

Ugo Rondinone, *No. 299*, 2003
Oil on canvas, 223 × 223 cm (87³/₄ × 87³/₄ in)
Sold: Sotheby's London, July 2008
US $505,000
(Estimate US $140,000–$180,000)

Wojciech Fangor, *M 72*, 1969
Oil on canvas, 142 × 143 cm (56 × 56¹/₄ in)
Sold: Christie's East, November 1993
US $403
(Estimate US $2,000–$3,000)

I don't know if Rondinone was riffing on Wojciech Fangor or Kenneth Noland or indeed Jasper Johns with his 'target' paintings. It didn't bother me when I showed Rondinone paintings at Boundary Road, and decided that it wasn't a rip-off as much as an homage. Of course, I could have just been using that argument to convince myself, as I thought the Rondinones looked very fetching on the gallery walls.

The prices above also demonstrate what a silly fashionista business art can be. Rondinone is hot, Fangor is not, one sold for $403 and the other for $505,000.

Fangor was clearly once hot when he had a Guggenheim retrospective in 1970, which promptly killed off his career as retrospectives have a habit of doing. But I guarantee you could mix up a group of Fangors with the Rondinones at his next Matthew Marks Gallery exhibition, and sell them all to the achingly hip New York cognoscenti.

Why are there no Israelis in your show 'Unveiled: New Art From The Middle East'?

Good question.

What was your most memorable studio visit?

I went to Julian Schnabel's studio in 1978 when he had just started working in New York and just before he had discovered the joys of broken crockery.

He was magnificent in the certainty of his own genius, a complete belief that he was the natural and only worthy successor to Picasso. I found him so winning and liked his paintings enough to find this not as toe-curling an experience as it sounds. He then went on to produce five years of quite brilliant paintings that the art world largely derided. These works will look like an extraordinary achievement if brought together to hang in a celebratory show. Let's hope some big-time museum in New York doesn't wait for Schnabel to die before it decides the moment is right.

Quick fire:

Damien Hirst or Tracey Emin?
Both.

Florence or Venice?
Both.

Junk food or home cooking?
Neither.

Monet or Modigliani?
Monet sometimes. Modigliani seldom.

Tony Blair or Gordon Brown?
Nigel Lawson.

Mountains or sea?
Both.

Baked beans or spaghetti hoops?
Neither.

Magritte or Manet?
Both.

Was
'Sensation'
your
high point
and have
you been
going
backwards
since?

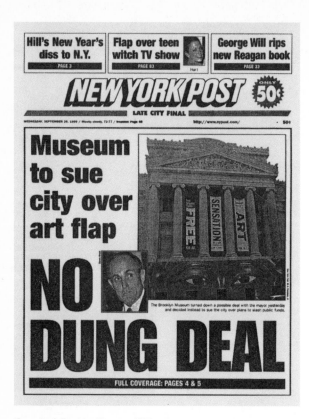

'Sensation', Brooklyn Museum, 1999

Was 'Sensation' your high point and have you been going backwards since?

Well, it is never nice to be told your best days are behind you. But you're probably right. I certainly was more dynamic once, building my advertising business and my art collection with ferocious energy. Now that I have fizzled out, I still enjoy putting on shows of art that I like and introducing new artists to our visitors, so I hope it makes it worthwhile to plod on.

If you have questions on any subject you would like Charles Saatchi to answer, send them to pkapublishing@googlemail.com

Author's acknowledgements:
Thank you to members of the public, and *The Times*, *Sunday Times*, *Independent*, *Sunday Telegraph* and *Art Newspaper* for their questions.

Picture credits: akg-images: 124; Alamy: 103T, 103TC (©Pictorial Press Ltd), 153 (©Photos 12); Courtesy of BBC Newsnight Review: 45; ©Glenn Brown. Gift of Charles Saatchi, 1999: 26; Courtesy of Cahiers du Cinéma: 151; Capital Pictures: 95; Courtesy of Sadie Coles HQ, London: 160 (©John Currin); Corbis: 110L (©Bettmann), 153 (©Michael Ochs Archives); ©Tracey Emin/DACS 2009: 136; ©Álvaro Felgueroso Lobo: 81B; H&E naturist magazine (www.henaturist.net): 144; ©Duane Hansen: 71; The Kobal Collection: 103BC (United Artists), 103B (Stanley Kramer/United Artists), 151 (Lucasfilm Ltd/Paramount); ©Jeff Koons 2009: 35; Courtesy Galerie Eva Presenhuber, Zürich/Photo: Stefan Altenburger Photography, Zürich: 168L (©Ugo Rondinone); ©photo: Daniele Resini: 50; Rex Features: 102 (©Everett Collection), 110C (Action Press), 151 (©United/Everett), 153 (KPA/Zuma); © Succession Picasso/DACS 2009: 148, 149; ©Liu Wei: 118; ©Richard Wilson: 29; Courtesy of Wyer Gallery: 161 (©Richard Moon); ©2008 Alessandro Zambianchi–Simply.it: 67.

Author photograph by James King

Phaidon Press Limited
Regent's Wharf
All Saints Street
London N1 9PA

Phaidon Press Inc.
180 Varick Street
New York, NY 10014

www.phaidon.com

First published 2009
©2009 Phaidon Press Limited

ISBN 978 0 7148 5747 3

A CIP catalogue record for this book is available from the British Library.

Printed in the European Union